On Obliteration

Emmanuel Levinas

On Obliteration

An Interview with Françoise Armengaud
Concerning the Work of Sacha Sosno

Translated by Richard Cohen

With a Foreword by Johannes Bennke
With an Epilogue by Dieter Mersch

Translated by Brian Alkire

DIAPHANES

THINK ART Series of the Institute for Critical Theory (ith)—
Zurich University of the Arts and the Centre for Arts
and Cultural Theory (ZKK)—University of Zurich

Original:
Emmanuel Levinas: *De l'oblitération*
Entretien avec Françoise Armengaud à propos de l'œuvre de Sosno
Éditions de la Différence, Paris 1990
© 2018, Estate Emmanuel Levinas

Photography:
© André Villers, ADAGP, www.adagp.fr

First edition
ISBN 978–3-0358–0144–6
© DIAPHANES, Zurich 2019

Layout: 2edit, Zurich
Printed in Germany

www.diaphanes.com

Contents

Foreword

The spoken word is often carelessly pushed to the margins of a work, the currency of which is considered the written word. This is especially true of a philosophical body of work which is known more for its ethics than its aesthetics. Here, instead of writing about something unsaid, we must recall a precarious moment which is not peripheral to the thought of Emmanuel Levinas but in fact central to it.

Levinas is generally considered a thinker of the ethical whose central concept, the face or *visage*, refers to a form of singular communication from face to face. The ethical moment takes place in the encounter with the Other, who appears to the senses and is the initial cause of thinking. In his early writings, this is closely connected to speech and the spoken: "The epiphany of the face is wholly language."[1] Even in his comparatively rare comments on aesthetics, the *visage* is a guiding concept. However, in his later works especially, Levinas repeatedly suggests that the *visage* or face does not appear in the moment of being seen:

> One may indeed look at the other face as a portrait or sculpture. But there are two words here: *visage* or face, and *dévisager*: that means looking at someone, but in a way which simultaneously pushes the face away.[2]

1 Emmanuel Levinas, "Philosophy and the Idea of Infinity," *Collected Philosophical Papers*, translated by Alphonso Lingis, Dordrecht 1987, p. 55.
2 Emmanuel Levinas, "Antlitz und erste Gewalt. Ein Gespräch mit Hans-Joachim Lenger über Phänomenologie und Ethik," in Christian Kupke (ed.), *Lévinas' Ethik im Kontext*, Berlin 2005, p. 17 [translated from the German].

Levinas thus sees the ambivalence of the *visage* in its visibility on the one hand and a form of not-seeing on the other, a seeing which allows us to glance at this hidden visibility. This is problematized in this dialogue with the concept of obliteration:

> There is in the idea of crossing out a certain modality, a certain obscurity in being, a certain drama in being, a secret in the truth. And in this sense I see a great justification for the whole theme of obliteration.[3]

In the appearance of crossing out, which is linked with the term obliteration, *an inner ontological drama is put on display*, the dynamic of which essentially lies in the non-visible. There is thus a close connection between obliteration and the face, which Levinas also expresses in the term "obliterated faces"[4] in the present dialogue, thus indicating an interfolding of ethics and aesthetics.

Nowhere did Levinas systematically develop a theory of art, and his scattered and relatively rare comments on aesthetics have so far been largely neglected. Wherever his readers have nonetheless asked about the face or visage in art, this has mainly concerned either his statements on literature or simply the distinction between image and idol.[5] This is certainly also due to the fact that Levinas himself spoke relatively little about art and the image specifically, and when he

3 See p. 40 in this volume.
4 See p. 35 in this volume.
5 See Uwe Bernhardt, "Die Jugendlichkeit des Werkes. Zum Status der Kunst bei Levinas," *Allgemeine Zeitschrift für Philosophie* 26 (2001), Heft 3, pp. 225–244.

did it was frequently with skepticism.[6] His comments in this dialogue are thus surprising. That Levinas agreed to have a dialogue about the artistic practice of obliteration is not just a sign of politeness. It was partially related to Sacha Sosno's body of work, of whom Levinas, with some reservation, says: "in some of Sosno's works there is a way of hiding which is suggestive, paradoxically, of a meaning."[7] It was also a matter of the inner logic of the dialogue itself, the possibility of opening an interval between the participants, and between them and the works of art.[8] The dialogue takes place in this interval and it seems as if it required this format to enable the necessary provocation to emphatic expression. Emphatic language is provoked which is closely connected to the work. This in turn corresponds to the fact that Levinas, in his later writings, no longer provides the work of art with language but instead locates it in the *interior* of the work itself.[9] The work of art accordingly requires its own private language. That is the provocation. The change of medium into discursive art criticism[10] thus becomes an essential part of the plastic or visual work of art itself.

6 See Catherine Chalier, "Préface. Brève estime du beau," in David Gritz, *Levinas face au beaux*, Paris, Tel-Aviv 2004, p. 41.
7 See p. 34 in this volume.
8 See Louis Marin, *De l'entretien*, Paris 1997.
9 See Levinas, *Otherwise than Being or Beyond Essence,* trans. Alphonso Lingis, Dordrecht and Boston, MA 1978. Françoise Armengaud, "Ethique et esthétique: de l'ombre à l'oblitération," in Catherine Chalier and Miguel Abensour (eds.), *Cahiers de l'Herne. Emmanuel Levinas*, Paris 1991, p. 507.
10 Richard Cohen emphasizes the role of art criticism and philosophical critique in Levinas. The function of criticism is principally to identify aesthetic effects, their classification in the history of art, and ethical moments. See Richard Cohen, "Levinas on Art and Aestheticism: Getting 'Reality and its Shadow' Right," *Levinas Studies* 11 (2016), pp. 149–194.

Starting from this inner connection between a work of art and its own language, any interpretation must remain problematic which simply takes the general assumptions of ethics and carries them over into the artwork. In German-language readings, the issue of art's ethics is summarized in the formula: *Can works of art have a face?*[11] But the question assumes a face-to-face encounter with the Other and thus already shifts our gaze to concrete artistic practice and its terminology. Among French-language readings, Françoise Armengaud in particular, following her dialogue with Emmanuel Levinas, systematized Sacha Sosno's artistic practice of obliteration.[12] Her semiotic reading, referencing Umberto Eco's remarks on visual codes, leaves the question open of the degree to which "fullness" and "emptiness" are appropriate terms for describing the wide variety of phenomena which can be encompassed by the term *obliteration*. Levinas describes this crisis of description as misery (*misère*),[13] simultaneously drawing attention to the original moment of obliteration in Sacha Sosno. For how can we make human misery and suffering visible and "strip off the false humanity in things"?[14]

Etymology of Obliteration

Etymologically, the French word *oblitération* originates from the Latin *oblitterare* and refers first of all to "painting over,

11 See Katharina Bahlmann, *Können Kunstwerke ein Antlitz haben?*, Vienna 2008.
12 Françoise Armengaud, *L'Art d'oblitération. Essais et entretiens sur l'œuvre de Sacha Sosno*, Paris 2000.
13 See p. 34 in this volume.
14 See p. 36 in this volume.

erasing."[15] Reviewing other dictionaries gives a series of synonyms and related words which relate to the action of deleting or canceling: "overwriting," "striking through," "blotting out," "concealing." *Oblitterare* is also cited as a reference to *oblino*, pointing in the direction of "forgetting" and "deleting from the memory."[16] The Latin prefix *ob-* refers to material obstruction: spatial distancing as delimitation, rejection, deferral, or concealment. The prefix returns in the concepts of opus, operation, and object and refers to a resistant element which is unable to be integrated. The suffix *-litéra* is sourced in *letter* and refers to language, word, text.[17] *Oblitération* thus refers to a crossing out, veiling, forgetting, or deletion of a textual or linguistic sense (or sense/meaning as such).[18] Obliteration is thus in a literal sense a form of deletion or erasure which implies a process of making something unrecognizable.[19] Used reflexively, this also includes a stroke that strikes out the already stricken-out. In Old French, *oblitération* primarily assumes a temporal meaning and indicates the surface of a sculpture faded over time by weather or repeated use (*Sculptures qui s'oblitèrent avec le temps*).[20] Obliteration here is a symbol of the passive occurrence of wear or of wearing

15 Karl Ernst Georges, *Ausführliches Lateinisch-Deutsches Handwörterbuch*, Leipzig 1880, Entry: oblittero, p. 1110f.
16 Ibid.
17 Alain Rey, *Dictionnaire culturel en langue française*, Paris 2006, entry: oblitérer, p. 1055.
18 See Françoise Armengaud, "De l'oblitération," in Danielle Cohen-Levinas (ed.), *Le souci de l'art chez Emmanuel Levinas*, Houilles 2010, p. 252.
19 Reinhold Esterbauer suggests the word "Unkenntlichmachung" as a German translation: "Das Bild als Antlitz? Zur Gotteserfahrung in der Kunst beim späten Levinas," in Josef Wohlmuth (ed.), *Emmanuel Levinas – eine Herausforderung für die christliche Theologie*, Paderborn, Munich, Vienna, Zurich 1999, p. 17.
20 Rey, *Dictionnaire culturel en langue française*, p. 1055.

away through time, its traces, its deletions, and the forgetting of its causes. In the medical terminology, obliteration refers to a material obstruction in the form of a vessel occlusion by a foreign body.[21]

The juridical-economical dimension of obliteration is preserved in colloquial French in philately. The term *collection d'oblitération* concerns stamp collections whose value is specifically based on their preserved cancellation markings (*cachet d'oblitération*).[22] It is a simple but effective juridical-economical principle: canceling stamps prevents their repeated use, thus negating their value.[23] The cancellation itself, however, generates a new aesthetic and economic value. The better the cancellation can be recognized (i.e. more central, more readable, including time and place) on the cancelled stamps (*timbre oblitéré*), the more valuable the collection object. The everyday occurrence of canceling a stamp, done in a readable way, causes its own desirability. The shape of the cancellation and the color of its ink registers place and time, gives the stamp its definition, delivers the letter to its intended recipients, and enters the stamp into a new form of circulation. *Timbre oblitéré*. The creation of value through annulment.

We encounter an analogous process in the stamping of tickets in a public transportation system. In short: obliteration, in its everyday usage in French, contains its own juridical-economical principle which is in effect everywhere barriers

21 Willibald Pschyrembel, *Pschyrembel Klinisches Wörterbuch*, Berlin 2017, entry: Obliteration.
22 Rey, *Dictionnaire culturel en langue française*, p. 1055.
23 A passionate collector defined it in this way: "Obliteration is an irremovable mark entered onto the stamp which is intended to annul the stamp and prevent its reuse." [translated from the French], Guy Maggay, "Les obliterations," http://marcophilie.org/x/x-int-i.html (accessed: 8/30/2018).

need to be overcome, thresholds where authentication simultaneously validates and devalues: public transit, cinemas, theaters, libraries, or online portals. "Tickets, please!" Its aesthetic value is based precisely on its validation by way of a stamp, imprint, rip, or puncture.

In both specialist and everyday language—particularly in the English-speaking world—a number of phenomena are covered by this term and have taken on a life of their own, specifically in the sense of *destruction*. The most common connotation in everyday English refers to destructive potential and invokes post-apocalyptic scenarios of nuclear devastation or appears in the context of the Holocaust as a reference to genocide.[24] The term's use in English has thus taken on a life of its own as compared to its French etymological origins. The term is also used in forensics as well as restoration. One speaks of obliteration in the context of deciphering handwriting or secret languages, for example, where chemical and physical processes are used to make erased handwriting legible again. Obliteration thus also refers to both illegibility and the reverse process of retrieving and restoring deleted and unavailable marks.[25] In German, the sense of "destruction, deletion"[26] is

24 David Patterson, *The Holocaust and the Nonrepresentable: Literary and Photographic Transcendence*, Albany, NY 2018, p. 118.
25 See Ramesh Kumar Pandey, Mahipal Singh Sankhla, Rajeev Kumar, "Forensic Investigation of Suspected Document for Alteration, Erasures & Obliteration," *Galore International Journal of Applied Sciences and Humanities* 2 (2018) Vol. 1, pp. 46–50, http://gijash.com/GIJASH_Vol.2_Issue.1 Jan2018/GIJASH004.pdf (accessed: 8/30/2018). See also https://dps.mn.gov/divisions/bca/bca-divisions/forensic-science/Pages/serial-number-restoration.aspx (accessed: 8/30/2018).
26 Lexikographisches Institut München (ed.), *Die neue deutsche Rechtschreibung*, Gütersloh 1996, entry: Obliteration, p. 695. Wissenschaftlicher Rat der Dudenredaktion (ed.), *Duden. Das große Fremdwörterbuch. Herkunft und Bedeutung der Fremdwörter*, Mannheim 2007, entry: Obliteration, p. 950.

included in dictionaries and lexicons, but this sense is not present in everyday usage and is used exclusively in a medical context. There it takes on the meaning of an obstruction, a blocked vein for instance. *L'Oblitération* thus presents problems for translation not only for the German but also for the English language. Terms like "forgetting," "covering," "obscuring," "destruction," or "annihilation" each narrow the meaning of *l'oblitération* to a single aspect. And even if every obliteration features something "unavailable," this translation cannot express the phenomenal side of the word. Even "erasure" remains problematic, as we are about to see. What, though, do Sacha Sosno and Emmanuel Levinas mean by obliteration?

Obliteration According to Sosno and Levinas

Alongside his work as a painter, sculptor, and photographer, Sacha Sosno also composed a number of journalistic pieces and theoretical writings (particularly relating to image). In conferences and exhibition catalogues, he repeats three motifs which are also characteristic of his artistic body of work: First, the rich field of art history and daily life, which includes works from cave paintings and contemporary art just as much as the experiences of human suffering he observed as a photographer in the 1960s in Biafra and Bangladesh.[27] These photographs would later form the basis of his first obliteration works around 1970. Second, he summarizes his understanding of obliteration in the formula: "Hide to show better"

27 See Alexandre Sochnowsky, *Biafra: proximité de la mort, continuité de la vie*, Paris 1969.

14

(*cacher pour mieux montrer*).[28] And finally, he lends the human gaze a vivifying power for the work of art and not just the materiality of the sculpture. The work emerges in its observation.[29]

Sacha Sosno's praxis of obliteration is, then, a child of human suffering on the one hand and its artistic visibility on the other. This rebellious child revolts against a circulation of images which also includes postcard motifs like those of Auschwitz. It grew up in an artistic milieu which explicitly broke with high culture and academicism and, because the process-oriented nature of artistic production played a central role, with the goal of "emptying painting."[30] Malewitsch's monochromatic painting, minimalism, Fluxus, and the attempt to break away from the prevailing art scene in Paris after World War Two were thus the breeding ground for the École de Nice. Sacha Sosno proclaimed this school in 1961 in the magazine *Sud Communications*, which he had cofounded under his legal name Alexandre Sochnowsky. As a reaction to abstract painting, its members sought to come closer to daily life, to concrete things, objects, bodies, and materials in favor of performative interaction with the public.[31] Sosno, for example, burnt his early paintings in view of the monochromatic works of Yves Klein and focused from then on in particular on the problematic appearance of his artworks in the world

28 Sacha Sosno, "Il n'y a pas d'images...," in Musee d'art moderne et d'art contemporain (ed.), *Sosno. Oblitération: peinture, sculpture*, Nizza 2001, p. 59. Here, he also presents his theoretical categories of the image, which are oriented towards those of Marie-José Mondzain und Georges Didi-Huberman.
29 This is especially clear in Sacha Sosno, "Il n'y a pas de sculpture!," in *Topique* 104 (2008), Vol. 3, p. 149.
30 André Giordan and Alain Biancheri (eds.), *L'Ecole de Nice*, Nice 2017, p. 15.
31 Rosemary O'Neill, *Art and Visual Culture on the French Riviera, 1956–1971. The École de Nice*, London, New York 2012, p. 103.

as image.[32] In his art, Sosno grapples in essence with the problem of the image and of perception,[33] a "hygiene of vision,"[34] specifically avoiding an orientation towards surrealism.

In 1988, Françoise Armengaud introduced Emmanuel Levinas to the concept of obliteration and thus to the work of Sosno. It remains the only location where Levinas says anything about obliteration. The source situation is for this reason quite meager. However, Levinas mentions literary and philosophical works in the dialogue which lend some contour to the concept of obliteration in view of the milieu. His affirmation of obliteration is "quite influenced by Nabokov and his observation about Gogol."[35] In the story *The Overcoat*, the subject is not "a protest against the injustices of the social order of his time,"[36] but rather, "cracks under its own weight and exhausts itself with wanting to be."[37] In his commentary entitled *The Apotheosis of a Mask*, Nabokov foregrounds the nakedness of the protagonist's vagabond spirit which is covered by the cloak. The cloak functions, according to Nabokov, as a kind of mask which does not cover the protagonist but rather *disrobes* him: "the making and the putting on of the cloak, is really his *disrobing* and his gradual reversion to the stark nakedness of his own ghost."[38] Only a few lines later he summarizes with the

32 Ibid., p. 102.
33 In another context, Georges Didi-Huberman analyzes the minimalist cubes of Tony Smith and refers to this problem as a dialectic interplay between alienation and its need to present itself. See: Georges Didi-Huberman, *Ce que nous voyons, ce qui nous regarde*, Paris 1992, p. 68f.
34 See "Hygiene des Sehens" in Sprengel Museum Hannover (ed.), *Nouveau Realisme. Revolution des Alltäglichen*, Ostfildern 2007, pp. 210–240.
35 See p. 40 in this volume.
36 See p. 34 in this volume.
37 See p. 36 in this volume.
38 Vladimir Nabokov, *Nikolai Gogol*, New York 1959, p. 146 (emphasis in original).

statement that "all reality is a mask."[39] Nabokov does not use the term obliteration but rather that of the mask, thus emphasizing concealment, secretiveness, false identity. Levinas, in referencing this, says that "reality [is] already obliterated,"[40] pointing to the ontological drama he sees in Nabokov's Gogol commentary, which to him is characterized by obliteration. In the act of covering up, an inner conflict reveals itself as concealed. Nabokov's analysis accordingly aims at literary structure and its relationship "to that secret depth of the human soul."[41] Here, obliteration appears other than through a striking through, namely in the fact that the protagonist dons the cloak, slips it on. A scenic moment unfolds here through literary means. Obliteration goes beyond writing and can thus not be reduced to writing alone. It possesses something iconic.

This iconic moment of obliteration is also supported in the dialogue by two notable comments by Levinas where he explicitly locates the face somewhere else, namely in works of art:

> Without mouth, eyes or nose, the arm or the hand by Rodin is already a face. But the napes of the necks of those people waiting in line at the entrance gate of the Lubyanka prison in Moscow [...] are—though otherwise—obliterated faces.[42]

These obliterated faces appear in this case through body parts, sometimes as the literary description of necks, other times as an arm or hand of a sculpture. Levinas also affirms the possibility that the materiality of the face can appear in a

39 Ibid., p. 148.
40 See p. 32 in this volume.
41 Nabokov, *Nikolai Gogol*, p. 149.
42 See p. 35 in this volume.

bodily and sensual way in art. There, it keeps the ambiguity of the face alive, a face which Levinas explicitly locates between visibility and invisibility.[43] Levinas also leaves no doubt in this interview that the human relationship is, for him, the site of the ethical. But art is able to show the ambivalence reigning there. Obliteration seems initially, in a temporal sense, to be obsessed with the past but without seizing hold of it. With Vladimir Jankélévitch's concept of "the samelfactive," Levinas points to the temporal dimension of obliteration in its close connection to the singularity of the unique moment, its irreversible becoming. "Once upon a time..."[44] The irretrievable singularity of the moment constitutes the obstructive character of obliteration. It is at home in the here and now, in the ephemerality of action. It is—and this is what distinguishes it from the trace—in essence not a result but an execution.[45] To emphasize the process-oriented nature of obliteration, we could also, from a conceptual perspective, speak of the *act of obliterating*: it is in the nature of obliteration that it conceals the obliterating act which caused its obliteration. We will therefore only occasionally speak of this *obliterating* act in the following.

43 On the topic of ambiguity, which Levinas also discusses as the double meaning of the phenomenon and its absence, see: Levinas, *Otherwise than Being.*

44 This fairy tale-like expression with which Levinas ends the conversation refers to a chapter in Michel Leiris, *Scratches. Rules of the Game I,* New York 1991, pp. 117–153. See also Levinas' critical commentary: Emmanuel Levinas, "Transcending Words: Concerning Word-Erasing," translated by Didier Maleuvre, *Yale French Studies,* no. 81, On Leiris (1992), pp. 145–150.

45 Compare comments on the trace in Sybille Krämer, "Das Medium als Spur und als Apparat," in Krämer (ed.), *Medien, Computer, Realität. Wirklichkeitsvorstellungen und Neue Medien*, Frankfurt a. M. 1998, pp. 73–94.

Erasure and Obliteration

In his commentary on Michel Leiris, Levinas draws out the double-edged nature of his concept of erasures. Leiris supplements his practice of writing with the concept of the homophones *biffures* (erasures) and *bifurs* (bifurcations). In this passage, Leiris invokes the image of a train ride where language, in being written, follows the switches or bifurcations (triggered by words, meanings, thoughts, and memories), determining that the train could also have taken another direction or even arrived back on the original track. Leiris' intention is less to follow these directions than to understand the moment of bifurcation, the transfer itself. ("I intended, rather, to emphasize the very act of bifurcating, of deviating [...]").[46] This network of tracks constitutes a space which, for Levinas, is essentially shaped by simultaneity:

> The originality of word-erasing lies in its positing of multiplicity as simultaneous and conscience as irreducibly ambiguous. Michel Leiris's memories such as they are narrated according to his "rule of the game" does [sic] not give the impression—curiously enough—of a temporal scheme. Rather, the ambiguity of word-erasing creates a space.[47]

This simultaneous space keeps a kind of ambiguity alive. Levinas connects this train of thought to the paintings of Charles Lapicque with the statement that one of the basic categories of modern art lies in its incompletion.[48] This specific

46 Leiris, *Scratches*, p. 239.
47 Emmanuel Levinas, "Transcending Words: Concerning Word-Erasing," translated by Didier Maleuvre, *Yale French Studies,* no. 81, On Leiris (1992), p. 147.
48 Ibid.

characteristic of a literary aesthetics of erasure concerns understanding this as an additive-spatial process which sustains ambiguity in the inconclusiveness and openness of the work.

Almuth Grésillon follows this interest of Levinas' but sees in the metaphor of *ratur* (erasure) a better option for describing the structure of *bifur/biffure*. It places the emphasis on the simultaneity of the double existence of loss and profit, lack and excess, emptiness and fullness, forgetting and remembering. Foregrounded in this metaphor is the ambivalent character of a visible erasure, the generation of the new through an act of negation.

> Being between both, between nothing and something, between loss and survival: the ambivalent space; this constitutes the true sense of erasure.[49]

According to Grésillon, this ambivalence can also be demonstrated etymologically. *Radier*, for example, can be traced back to the double senses of "annul, delete" and "illuminate like lightning."[50] Erasures extinguish something but show this destruction as such in the graphic appearance of writing. Erasure is something graphic. It not only appears: it can even intensify presence by ~~crossing something out~~. Although Grésillon's remarks focus primarily on writing, she also sees this same phenomenon in musical notation. As a composer and pianist, Levinas' son Michaël referred to the erasures in music notation as "neuralgic moments" which express "something unable to be integrated."[51] This is, according to him, an es-

49 Almuth Grésillon, "La rature," *La mise en œuvre: itinéraires géné-tiques*, Paris 2008, p. 90 [translated from the French].
50 See ibid., pp. 88–90.
51 Michaël Levinas, "De la rature et de l'accident dans le processus de la composition musicale," *Genesis* 1 (1992) Vol. 1, p. 116.

sential feature of modern musical composition. It is thus no wonder that Grésillon finds a conception of literature on the part of artists, psychoanalysts, philosophers, and literary critics which starts from a position of erasure: *Lits et ratures!*,[52] *Lituraterre*,[53] *Le littératurer*.[54] Now, by means of *critique génétique*, artistic and, in this case, literary processes of production can be reconstructed and interpreted with the help of materially-existing witnesses of their creation. On the basis of manuscripts, erasures can be described and systematized in their internal logic and graphic appearance. The ambivalence of erasure can be prove to be a productive negativity and media and theories can be found which describe this specific negativity.[55]

This systematic method itself conceals a number of problems. The first of these is syntax. When Grésillon writes that "erasure deletes the already-written,"[56] we are confronted with a constructed ideal norm of erasure where a clearly recognizable form (subject) erases something ~~still legible~~ (object) with a clearly recognizable function. The way Levinas reads the works of Sosno or Gogol's *The Overcoat* shows something else, however: there, the point is not to verify *what* has been crossed

52 See cover image by Francis Picabia, based on an idea from Marcel Duchamps, *Littérature* 2 (1922), Vol. 7.
53 Jacques Lacan, "Lituraterre," in *Littérature* 1, Heft 3, 1971, pp. 3–10.
54 Raymond Queneau, *Le Chiendent*, Paris 1956, p. 295.
55 See Almuth Grésillon's condensed presentation of *critique génétique* in "Critique génétique und génétique musicale," https://beethovens-werkstatt.de/prototyp/expertenkolloquium/critique-genetique-und-genetique-musicale/ (accessed: 8/30/2018). See also the collection by Lucas Marco Gisi, Hubert Thüring, and Imgart M. Wirtz, *Schreiben und Streichen. Zu einem Moment produktiver Negativität*, Göttingen 2011, especially Uwe Wirth, "Logik der Streichung," pp. 23–45 and Hubert Thüring, "Streichen als Moment produktiver Negativität," pp. 47–70.
56 Grésillon, "La rature," *La mise en œuvre*, p. 83 [translated from the French].

out, made illegible, or deleted, but rather *that* there is an obstruction which points to a human limitation. The emphasis thus shifts from that which has been crossed out to the resistant appearance of its unrecognizability: in Gogol, it is the allegorical cloaking of the inner drama of being's self-obscuring, in Leiris the rising ambiguity through simultaneous narrative.

Moreover, literary studies do emphasize the ambivalent character of erasure (presence and negation), but the medium of writing remains the essential focus. The character of negativity is thus based on a questionable analogy between language and memory.[57]

How, though, can insights into erasure help us better understand erasure? According to Almuth Grésillon, the essential feature of erasure is its ambivalent character between the visible and invisible, between the invisibility of cancellation and the visibility of crossing something out. The inner logic of negation and its graphical dimension have a double-edged nature. Although here Grésillon is primarily systematizing the logic of erasure, she also ascribes a generative power to it. The forms of this logic can be expressed through allegories (Gogol) or through a simultaneous space of ambiguity (Leiris) or, in the case of Hélène Cixous, whom Grésillon briefly mentions, through a stuttering form of writing concerned with self-withdrawal, in her case remorse.[58] This ambivalence is con-

57 This problem now has its own independent secondary literature, oriented primarily towards Freud's *Wunderblock*. See: Jacques Derrida and Jeffrey Mehlman, "Freud and the Scene of Writing," *Yale French Studies*, no. 48, French Freud: Structural Studies in Psychoanalysis (1972), pp. 74–117. See also: Burkhardt Lindner, "Der Autor Freud," in Joachim Pfeiffer and Hans-Martin Lohmann (eds.), *Freud-Handbuch: Leben – Werk – Wirken*, Stuttgart, Weimar 2013, pp. 232–237.
58 Hélène Cixous, "Sans Arrêt, non, État de Dessination, non, plutôt: Le Décollage du Bourreau'," *Repentirs, catalogue d'exposition,* Paris 1991, pp. 55–64. In English: Hélène Cixous, "Without End, No, State of Drawing-

sequently discussed as a productive negativity where material traces of erasure represent testimonies of negation. These testimonies are identified as generative potential in the process of artistic creation.

In one passage of the dialogue, Levinas rejects the metaphor of erasure with the justification that obliteration better expresses the momentary, singularity.[59] If we recall that obliteration is semelfactive, i.e. indicates a temporal moment of irreversibility, then we can tentatively arrive at the thesis that obliteration, in contrast to erasure, highlights the temporal moment of processuality. The process, in the completion of its appearance, is indeed simultaneously concealed, and yet attested to by material traces in its inability to be integrated. In short, obliteration would first of all be the attempt to keep the inaccessible element of time alive—obliterating as process. It is therefore not the case that every erasure has an obliterative character, even if every obliteration is an erasure in the ambivalent sense of destruction and graphical appearance. Om s ions, ███████,, and ~~censorship~~ are not sufficient for obliteration. Levinas' cautious affirmation of the works of Sacha Sosno seems to come from this as well, of which he says that "there is a way of hiding which is suggestive, paradoxically, of a meaning."[60] Obliteration cannot be reduced to the appearance of writing or scribbles which have been crossed out or erased. It is essentially temporal.

We can more easily visualize this distinction with the example of the palimpsest. In the framework of erasure, scratched or scraped off pages of parchment or papyrus are

ness, No, Rather, The Executioner's Taking Off," *Stigmata*, Oxford, New York 2005, pp. 16–29.
59 See p. 31 in this volume.
60 See p. 34 in this volume.

discussed as an early form of erasure.[61] The palimpsest is spatial (the manuscript pages), for the most part hierarchically structured (stratification of central discourses), has the character of a work, and is oriented primarily towards the medium of writing (the *telos* of philology is the deciphering of illegible texts). Obliteration, in contrast, is temporal (semelfactivity), focuses on something unable to be integrated and thus has an obstructive character (negativity), is process-oriented (inconclusiveness, openness), and is not oriented towards writing but rather primarily towards the image (lightning-like flash). The iconic aspect, especially, clarifies the logic of obliteration and its need to be differently described.[62] The inner logic of the work of art requires, according to Levinas, a corresponding language. Exegesis as art criticism is also conceptual criticism.

The concept of negativity, for example, in the sense of graphical forms of negation, is thus not satisfied. *Something* (usually still legible) is erased. But the works of Sosno and Levinas' commentary show that negativity needs to be thought of much more radically with reference to human finiteness and that its iconic presence has a testimonial character. Obliteration instead concerns indeterminate negations. When Jean-François Lyotard says that he sees the task of the avant-garde as "bearing witness to the indeterminate," we hear not only the indeterminate negation in obliteration but also the ethical dimension of Levinas.

61 See Irmgard M. Wirtz, "Lesen und Streichen. Erica Pedrettis Tagebuch-Palimpseste," in Marco (ed.), *Schreiben und Streichen,* pp. 325–339.
62 See Johannes Bennke, "Obliteration als mediale Praxis. Emmanuel Levinas als Medienphilosophen lesen," in *Forum Medienphilosophie* [forthcoming].

In the art of obliteration, yes. It would be an art which exposes the ease and lighthearted casualness of the beautiful, and recalls the wear and tear of being, the "repairs" which art covers over, and the visible or hidden erasures in art's persistency to be, to appear and to show itself.[63]

Levinas expresses here his skepticism towards art (the perfection of the beautiful) while equally affirming that art is able to recall a temporal dimension which announces itself in visible traces (fading). When Levinas writes at several points in *Totality and Infinity* a variation of "ethics is an optics," he is orienting himself not towards the standard of objective vision but to the act of witnessing. Seeing a face means witnessing it. From the point of view of this ethical demand, obliteration provides faces to see which were not previously there. It is not just *anything* that is being erased; it is rather something unable to be integrated, something inaccessible. An act of showing plays itself out in obstruction. Showing simultaneously conceals. An obstruction is witnessed. *Cacher pour mieux montrer. Showing≠witnessing*. Obliteration is characterized essentially by a disruptive effect and shows the ambivalence between the inner logic of negativity and the iconic compulsion to appear. It is irretrievable singularity, irreversible becoming, an ambivalence of negativity and affirmation which is at play in obliteration. This concerns less a melancholy of the irretrievable loss of the past and much more, in distinction from Heidegger, a "flight from being-toward-death" with artistic and linguistic means. In the gesture of reservation—whether due to ineptitude or selflessness (*dés-inter-essement*)—something new emerges. Obliteration thus refers, apart from its conceptual characteristics, to an always-specific artistic

63 See p. 31 in this volume.

praxis. Thinking about art, according to Levinas, cannot occur without this ambivalence between negativity and affirmation. This is a practice of art which is able "to effect an irruption in the pretentious sufficiency of being, which values the already accomplished, and to overthrow its heavy densities and unperturbed cruelties."[64]

64 See p. 28 in this volume.

Emmanuel Levinas

On Obliteration

**An Interview with Françoise Armengaud
Concerning the Work of Sosno**

The encounter between Emmanuel Levinas and Sacha Sosno is not the product of chance. Think of the philosopher's reflection in *Humanism and the Other*: "The Other who manifests himself in a face that breaks through, as it were, his own plastic essence, like a being who would open the window where his countenance nonetheless already took form."[1] Does he not best permit clarifying the ethical implication of the work of obliteration, beyond aesthetics?

I have tried to steer the following interview toward the debate having to do with the relations between art and ethics. The text I have just cited resonates for me with an astonishing philosophical "premonition" of what Sach Sosno's practice of obliteration might mean.

Emmanuel Levinas has written little up to now on art in general, but it was when reflecting on Jean Atlan's paintings that he recently affirmed that the "tension of art, lived between man's despair and hope" is a struggle "as dramatic as the disclosure of the True and as the imperative exigency of the Good." This leads him to see in artistic engagement "one of the privileged modes for man to effect an irruption in the pretentious sufficiency of being, which values the already accomplished, and to overthrow its heavy densities and unperturbed cruelties."

This interview thus pursues a Levinasian meditation on art, based in Sacha Sosno's work of obliteration.

Françoise Armengaud, 1990

—A first excerpt of an english translation of this interview appeared in: Emmanuel Levinas, Armengaud, Françoise, "On Obliteration: Discussing Sacha Sosno," in *Art & Text* (1989), Nr. 33, pp. 30–41. For this publication the translation was revised again.—
1 Emmanuel Levinas, "Meaning and Sense," in *Collected Philosophical Papers*, translated by Alphonso Lingis, Dordrecht 1987, p. 96.

Françoise Armengaud: *Professor Levinas, would you see in the "obliteration" of Sacha Sosno the venture of redeeming art, relative to the ethical exigency, from its perhaps faulty intention, that is to say, according to the expression which you yourself used in* Difficult Freedom, *a striving "to give a face to things"*[1]*?*

Emmanuel Levinas: You say "redeeming" as if it were a sin! I am not entirely in agreement with this. As for expression: "the art which gives a face to things," for me it should not be used to denounce some sort of idolatry. Quite to the contrary, I mean by this the animation of matter by art, where "expression" alleviates the weight of brute matter, its heaviness of being-there. I do not have the impression that the human face, or the characteristics of this face which appear through art should be redeemed. If art can inspire distrust, it is for other reasons. The perfection of the beautiful imposes silence without caring for about anything else. It is the guardian of silence. It lets happen. It is here that aesthetic civilization has its limits.

Doesn't it have the eloquence to protest against evil?

Yes, which renders one indifferent to the world's suffering, and installs itself in this indifference.

— A first excerpt of an english translation of this interview appeared in: Emmanuel Levinas, Armengaud, Françoise, "On Obliteration: Discussing Sacha Sosno," in: *Art & Text* (1989), Nr. 33, pp. 30–41. For this publication the translation was revised again.

1 Emmanuel Levinas, "Ethics and Spirit," in *Difficult Freedom: Essays on Judaism*, translated by Seán Hand, Baltimore 1990, p. 8.

However, doesn't the image act in its own way by inducing a contemplation, a mood, a disposition of being?

One of the commencements of art is to think the real in its image—in its memory—and thus perhaps in its past; it is being which is heavy, tangible, solid, good to hold, usable and useful, disengaged of its burdens or its ontological properties, in order to let himself be contemplated. Contemplation which is *dis-inter-estedness*. Furthermore, isn't contemplation a generosity of the self, a gift-to-the-other, a benevolence which interrupts the *inter-ested* effort of persevering in being? I nonetheless wonder whether this ethical condition of the aesthetic is not immediately compromised by those joys of the beautiful monopolizing the generosity that have made them possible.

In defining the beautiful as the object of a disinterested satisfaction, Kant made disinterested contemplation the mark and vocation of art.

I have just made this concession, specifying, however, that the ultimate does not reside there. But already there, there is a relation to the Other.

Is the disinterestedness which is indeed characteristic of art not the greatest disinterestedness?

To be dis-inter-ested. "Not being to death," I write "dis-interest" in three parts, as you know. It is always a positive relation to the Other, insofar as he can matter to me more than my being.

Don't you think that one could recognize an ethical dimension in obliteration?

In the art of obliteration, yes. It would be an art which exposes the ease and lighthearted casualness of the beautiful, and recalls the wear and tear of being, the "repairs" which art covers over, and the visible or hidden erasures in art's persistency to be, to appear and to show itself.

Doesn't Susno make us aware of a triple fact: first, that reality is obliterated; second, that the perception we have of it is obliterated; and finally, that we are conscious of neither one nor the other?

Certainly. And after all, perhaps the metaphor of obliteration is better than that of erasure. It expresses a moment, non-renewable to be sure, but lived through, which has had its moment as one can have one's time, and, thus, bears all the melancholy as well as all the rewards of what is unique or the "semelfactual," as Jankélévitch would say.[2] Apropos of this notion of obliteration, I think of what Nabokov says of Gogol and, more particularly, of his story entitled *The Overcoat*.[3] The very distinctive comic aspect of this work which at the same time would be pathetic, comes from a certain disgrace or heaviness of the being against which the main character exists in his unicity. It is a disgrace which occurs in the very

2 See Vladimir Jankélévitch, *Philosophie première: introduction à une philosophie du "presque,"* Paris 1954, pp. 200–201. The prefix of this neologism is from latin, semel, "once," "a single time."
3 Vladimir Nabokov, *Nikolai Gogol*, New York 1944, pp. 139–150. *The Overcoat* (revised Constance Garnett translation) can be found in *The Complete Tales of Nikolai Gogol*, vol. II, edited by Leonard J. Kent, Chicago 1985, pp. 304–334.

language of Gogol—a positive trait of his art—as a style losing its way, for example, in needless details and in pleonasms. Reality is shown to be already obsolete, already obliterated, as Sosno's art would have it. You know the plot of this story. It is about a minor civil servant, a conscientious copyist—we are in an age of bureaucracy without typewriting!—who has never been able to get a promotion. He has certainly tried to advance in grade; to justify promotion, in a letter he copied it was a matter of making a slight modification, putting into the dative several proper names which in the original were in the accusative. "Impossible! Then give me something to copy!" says the candidate. Existence of the obliterated, a soul enclosed in its modes of appearing, incapable of getting away from it, incapable of getting out. The mechanical plated over the living, as Bergson would have it, to explain the comical.[4] Such is the overcoat of his civil servant uniform that the tailor can no longer mend. Expelled from his forms, is he going to get a new overcoat? An impossible luxury! But the utmost effort is made. An ideal has entered into a life without issue, the possibility of getting out in every sense of the term. But he is stripped of his belongings by a thief the very evening of this first departure, when after several hours of strolling haphazardly he stops in front of a store window. What follows is collapse, illness, death, and then the fantastic past of this existence without being. A phantom's vagabondage in the nights of Saint Petersburg, a specter pulling off the overcoats of passersby. A ghost's existence, compensation for an impossible reality. Obliterated existence.

A symbolic detail—unnecessary for the progression of the story: the tailor who condemned the aged overcoat and who

4 Henri Bergson, "Laughter," in *Comedy*, edited by Wylie Sypher, Garden City, New York 1956, pp. 61–190 (see especially pp. 117–127).

made the new one, had a snuff box bearing the image of a general. But the general's face was already worn into a hole by the user's finger, and the hole covered over with paper. Another obliteration. The whole story can be read under the sign of this obliteration. All the main character's gestures are tangled up and delayed, cover over some hole, are a resumption. While still the owner of his overcoat, the copyist stops "like everyone else" in front of the fashion shop, and finds nothing else to say than: "Well, those Frenchmen!"

Can one say that the art of Gogol thus reinterpreted clarifies in its turn something about the art of Sosno?

Does Sosno's art thus aim to rediscover in all its reality the trace of its own constriction by some foolishness of its very appearance? Like the fiancé in Gogol's *The Marriage*, who at the very last moment of the ceremonial formalities saves himself by jumping out the window? Or like those needless details I have already mentioned, those pleonasms, which Nabokov signals, such as the "two Russian muzhiks" in *Dead Souls*.[5] Doesn't this sound like "two mortal men"? Comic or tragicomic.

As if redundancy obliterated the message?

Yes. Likewise a needless detail, as when he says: "It was six o'clock or a little later." An overload. When you read Gogol, you often have the impression of a language which voluntarily gets muddled by a brusk conformity to the turns of what "one says" and to commonplaces.

5 See Nabokov, *Nikolai Gogol*, p. 76.

A sort of obliteration by the trivial which is, like you say, at the source of a comic effect?

A comic sadness, an obliteration if you wish. Life is deformed or misunderstood in its forms. Nabokov rebels when a protest against the injustices of the social order of his time is attributed to Gogol. Perhaps Gogol does not in fact expose the abuse of social life, but rather misery, the human constitution, which also cannot evade the social adventure.

Humanity is thus burdened, overloaded... Does this correspond to the "obliteration by fullness" as Sacha Sosno practices it?

But also by emptiness. It is the misery. The photographs which marked his activity at a certain moment of his genesis were obliterated by the unbearable, this is the term you have used. As when you are shown the famine of the Third World, the parents who do not have bread to give to their children. Speaking of obliteration in art, it is significant that Sosno uses geometric shapes. The incompletions are also significant. The work is never finished. And the work is never finished because reality is always off the mark and, in this sense, obliterated. But I take issue with the sort of obliteration which consists simply in covering the face with a purely geometric surface. This remains abstract and does not integrate what is covered over. Of course, to cover over is to hide. But in some of Sosno's works there is a way of hiding which is suggestive, paradoxically, of a meaning.

A way of stripping the plastic off the face? Of inciting the look to reconstitute, but also to search for, something else?

I liked that remark, where you say, not that there is nothing to see, but that there is much to see, that there is more to see, to see and to see.[6] Sometimes without distinction between what obliterates and what is obliterated. This means purely and simply hidden.

And yet Sosno seems very happy with this. He puts a geometric shape over the face. He likes that!

Isn't there a difference between obliterated faces and obliterated torsos?

Despite the different ways of being a face. Without mouth, eyes or nose, the arm or the hand by Rodin is already a face. But the napes of the necks of those people waiting in line at the entrance gate of the Lubyanka prison in Moscow, in order to transmit letters and packages to parents or friends—arrested by the GPU, according to Vasily Grossman's *Life and Fate*—napes which still express anguish, anxiety and tears to those who see them in the waiting line, are—though otherwise—obliterated faces. Can Sosno's obliteration, by means of a square placed over the face, by its brutal negation, have the same signification, the same profundity?

Allusion to Sacha's architectural practices: houses are also faces, and for this reason, equally obliterable.

In houses there are hidden planes, there are incomplete things. Certain forms of obliteration that you have shown me contribute mystery to the harmony of what remains visible. And in some of Sosno's architecture there is a secret. But

6 Allusion to a first draft of "Sosno or the Art of Obliteration."

actually there is no mystery; or rather, there is no mystery in this secret.

Consider the inhabitants of these houses. They will therefore inhabit a secret. Isn't this strange?

It is what happens in houses that is mysterious. Obliteration before all art! To return to the earlier questions, it is obvious that obliteration strips off the false humanity in things. But is this the function of all art?

A very important question! What is immoral in the Mona Lisa, to the contrary, would be its perfection in a world of suffering and evil, and in the drama which is played around us in the eventfulness of being and appearance.

To obliterate would then be at once to cross out and to expose the scandalous?

It would be the ethical moment, but this is not true of all art. Nabokov recognized it with regard to Gogol. He doesn't mean to reduce it to the social misery of the main character. It is not because society is unjust that the main character of *The Overcoat* is miserable. It is being which cracks under its own weight and exhausts itself with wanting to be. The social problem is only one of the modes of this ontological drama. Obliteration would have an ethical dimension by effecting what you call "the inverse of the magical operation of art."

As if one of the results of obliteration would be to make us aware of the role of the non-sensible which necessarily conceals the human face or body.

Why obliteration? Because this secret obtuseness of the face is scandalous. Obliteration shows the scandal; it recognizes it and makes it recognizable. It is full of compassion.

Doesn't obliteration make the intuition of a secret hidden in the shape of the human body more obvious, more flagrant? I am thinking of the observation in the Zohar which Sacha once quoted to me: "The very shape of the human body hides a supreme secret."

Yes, Sosno likes the *Zohar*. He makes more of the *Zohar* than he does of the Bible, in any case, a lot more than the Siddur, the Prayer Book! "The very shape of the human body hides a secret." One could argue about this. I think that the secret is misery, mortality. Perhaps it is a secret without mystery, misery without mystery. The straightforward look sees death before itself... There is a secret in misery. And a commiseration. I say this without the *Zohar*, I know nothing of Kabbalah.

Perhaps in this text there is also the idea that the proportions of the human body, if we know how to read them, reveal to us something about the secrets of the construction of the universe?

Maybe the *Zohar* develops this in a precise manner. But I know nothing about it. For me deliverance from the ontological drama is to be sought in the possibilities of the interpersonal relation.

Obliteration denudes, uncovers, or indeed covers. Both this opening and this closing seem as well to inflict a wound on something. On what exactly?

On someone! If there is obliteration—by opening or by closing, it is the same thing—there is a wound. But its significance for us does not stem from the principle that it tears up, but rather in the man who suffers it, and in the Other where it gives rise to our responsability.

Would you see in addition a link with the breaking of idols?

No, I don't want to enter into that thematic. I have ruled it out in advance! Obviously, there are reasonable or pious monotheists who think that the museums are full of figures that one must neither draw nor, above all, sculpt... But I am not afraid of idols in this sense!

Having agreed that aesthetics is not ethics, and that art could not replace religion; art, and especially what you have called the "art of obliteration," involves, we can now affirm, a veritable window onto ethics.

For me, true religion is religion thought on the basis of obligation and the order of the word of God inscribed in the face of the other man.

Aesthetics, art, designates a domain, or a kingdom, which precedes the kingdom of God and which can cure me of my hold on things which results from my perseverance in being. The image is a lesson in disinterestedness. A mature humanity should be able to think something other than being, to escape enchantment by what is. In contemporary philosophy, and this is its modernity, the only order that would be divine is that of art. One thinks of Heidegger, when he speaks of art.

And Valéry, in the *Song of the Columns*:
 Sweet columns, O
 The bobbins' orchestra!
 Each one confides its own
 Hush to the unison.[7]

If obliteration does not go so far as to make the image a word, and if it preserves the vocation of art to be the "guardian of silence," does it not introduce an interruption into that other interruption of the word which is the image?

The word is an important mediation, because it attests to the relation with someone.

But the position of a body in space says something, a sculpture offers itself as a model, as a word of address, an injunction. It proposes something, it calls for a response.

Obliteration, I agree, makes for talk. It invites talking. You say obliteration interrupts the silence of the image. Yes, there is a call from the word to sociality, to being for the other. In this sense, obviously, obliteration leads to the Other.

We are even obligated by it.

Which does not mean that it suffices to cross out!

But obliteration is not only crossing out!

7 Translation above by Vernon Watkins; Paul Valéry, "Song of Columns," in *An Anthology of French Poetry from Nerval to Valéry in English Translation*, edited by Angel Flores, Garden City, New York 1962, p. 276.

There is in the idea of crossing out a certain modality, a certain obscurity in being, a certain drama in being, a secret in the truth. And in this sense I see a great justification for the whole theme of obliteration.

Would obliteration then be this "passion," this loss which permits the image to signify otherwise, otherwise than through the image?

Perhaps indeed. My yes is quite influenced by Nabokov and his observation about Gogol. The man of Gogol is the man of obliteration. All the burdens, all the obstacles accumulate in the *ob*. In the end, obliteration is human finitude. There remains one question: to what extent can the notion of the art of obliteration be applied to Leonardo da Vinci? I return to the Mona Lisa!

Obliterable or already obliterated?

In the latter case, obliteration would become a concept essential for understanding art. Think of it: people come from all over the world to see the Mona Lisa, and you say to them: "It is already obliterated!"

Would you then be speaking of mystery or of secret?

There's the secret. The colors would have to be rosier, the look more profound...

It is all the contingency of what is actualized, and which comes to obliterate possibilities...

In fact even when obliterated it must still sing. Obliteration must sing. A song, however is not necessarily something joyful. It should be moving. Unicity, the "one time," is something that is still stirring in obliteration. The time limit. The ticket which is no longer good for travelling. The semelfactuality of existence which calls to us.

It is the finitude in time.

Yes, which means. "This has already taken place." One always comes back to the human condition. This suffering, this secret, this being put into retirement... One time, yes, but not twice! On a radio show I heard it said of a poet—I think it was Rilke—that he became blind, and who said his mother suffered a great deal, not from that fact that he could not see, but because he could no longer see.

In the end, art represents things as having come from a deep past. "Once upon a time"...

Paris, March 17th, 1988.

André Villers

Photographs

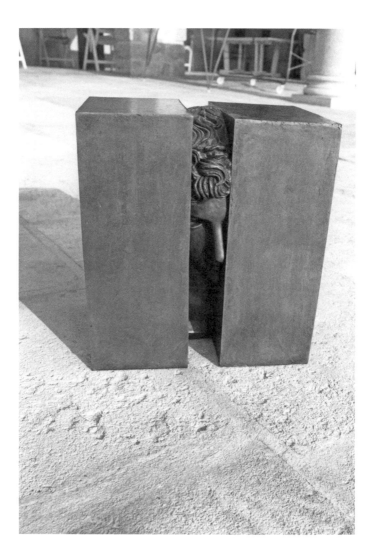

Le malléable l'emporte sur ce qui est dur, 1983.
Bronze, height 32 cm.

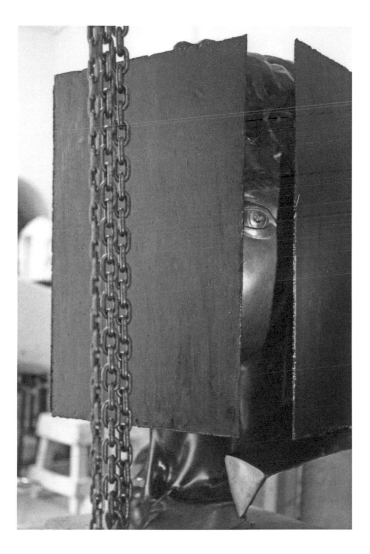

Il tient son mérite caché, 1985.
Bronze and steel plate, height 111 cm.

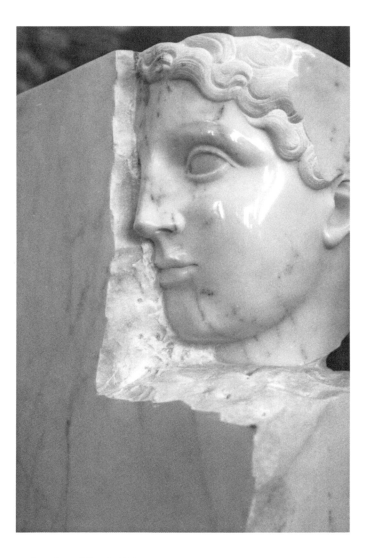

Et où est le problème?, 1989.
Marble, height 60 cm.

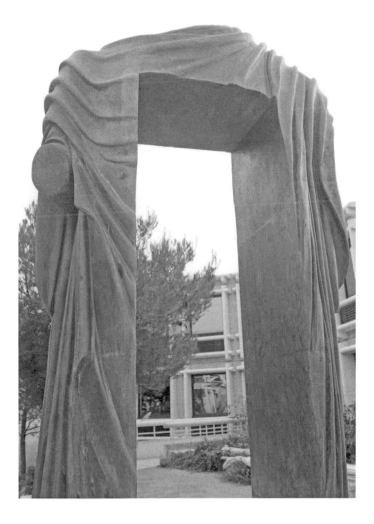

Drapé dans le vide, 1988.
Bronze, height 310 cm.

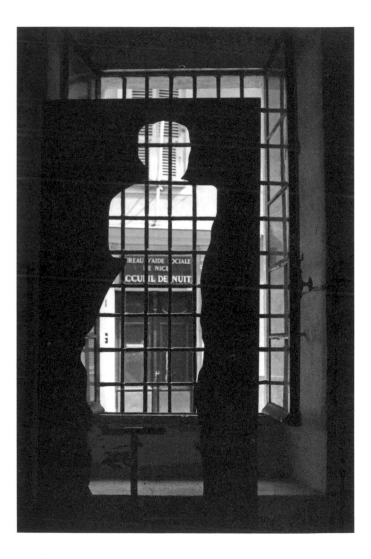

Ce qui est creux devient plein, 1987.
Steel plate, height 200 cm.

Tête aux quatre vents, 1980.
Bronze, height 32 cm.

Hommage à Arman, 1987.
Steel plate, height 200 cm.

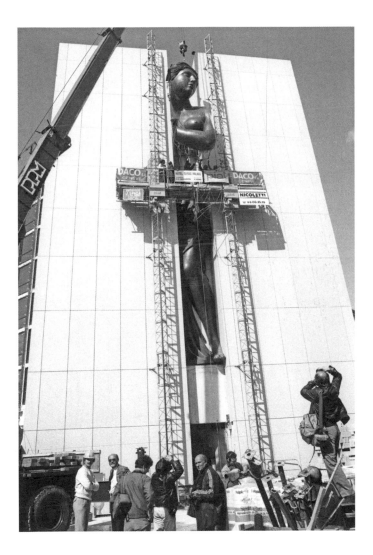

Il faut en toute chose préférer l'intérieur à l'extérieur, 1987/1988.
Bronze and granite, height 26 m. Hôtel Elysée Palace, Nizza.

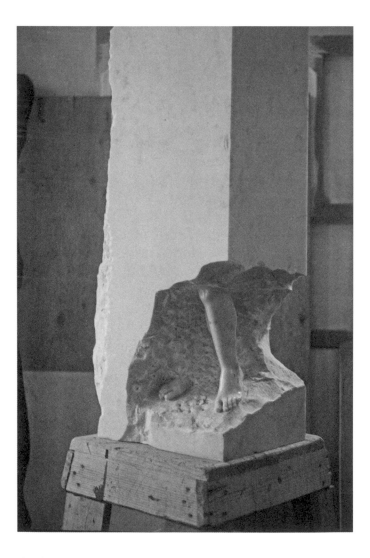

Il ne faut pas que le poisson sorte des profondeurs, 1987.
Marble, height 170 cm.

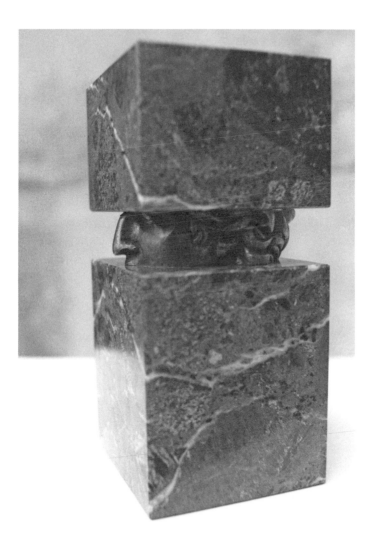

Les lendemains qui chantant..., 1987.
Bronze and marble, height 22 cm.

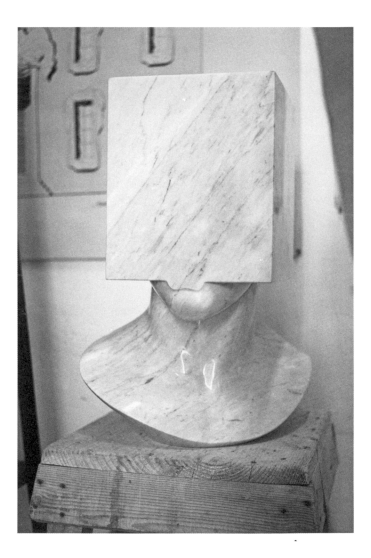

Tête au carré, 1985.
Carrara Marble, height 60 cm.

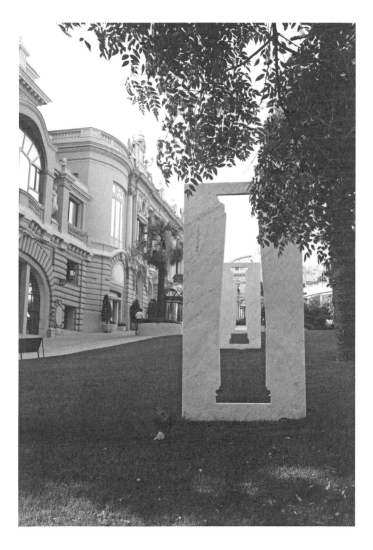

Moi seul suis dans l'obscurité, 1988.
Marble, height 200 cm. Marisa del Re Gallery, New York.

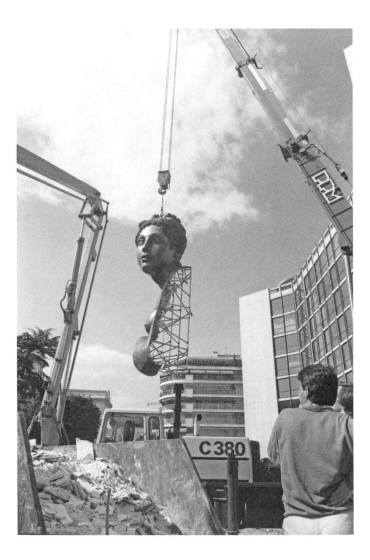

Erection of one of the Elysée Palace Statues.
Nice, 1988.

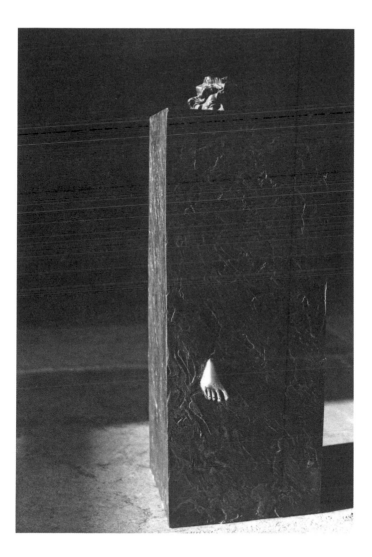

Tranquille, 1980.
Bronze, height 40 cm.

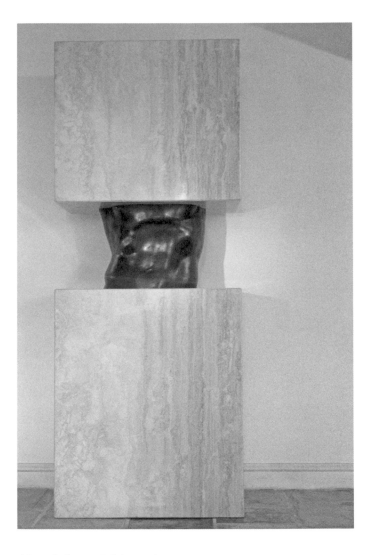

Il faut résolument le faire savoir, 1983.
Bronze und stone, height 200 cm.

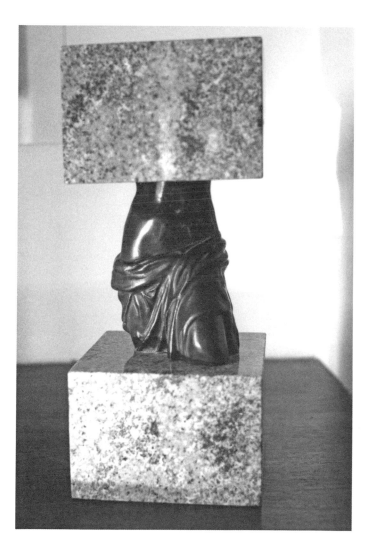

Sans titre, 1983.
Bronze and stone, height 43 cm.

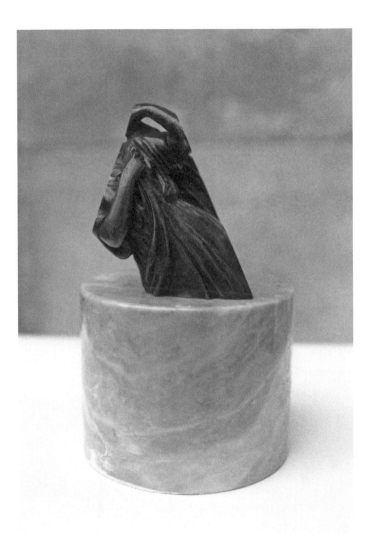

Qui réunit tous les temps, 1989.
Bronze, height 12 cm.

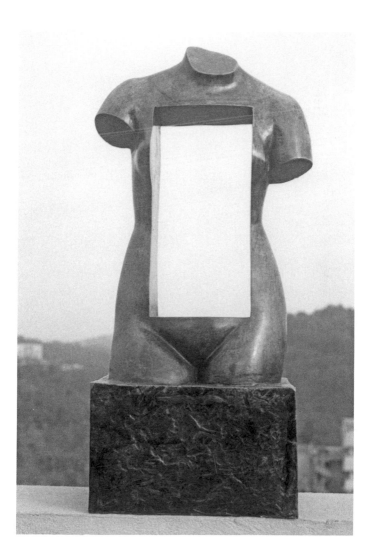

Vénus oblitérée, 1980.
Bronze, height 48 cm.

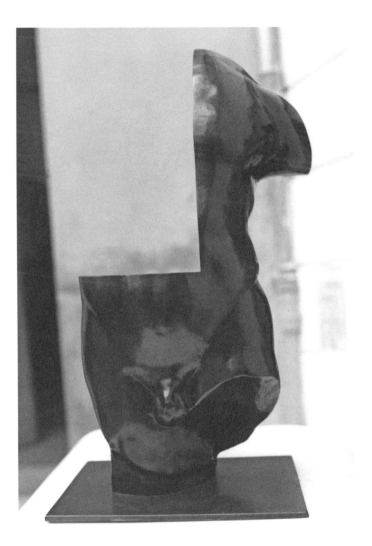

S'il a des défauts il s'en défait, 1979.
Bronze, height 51 cm.

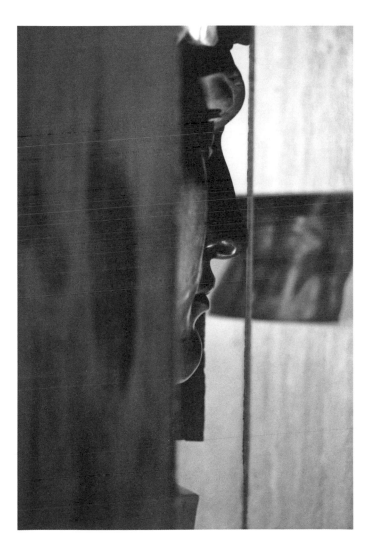

Il tient son mérite caché, 1985.
Bronze and steel plate, height 111 cm.

Moi seul suis dans l'obscurité, 1989.
Blue granite, height 200 cm.

Ce qui est creux devient plein, 1987.
Steel plate, height 200 cm.

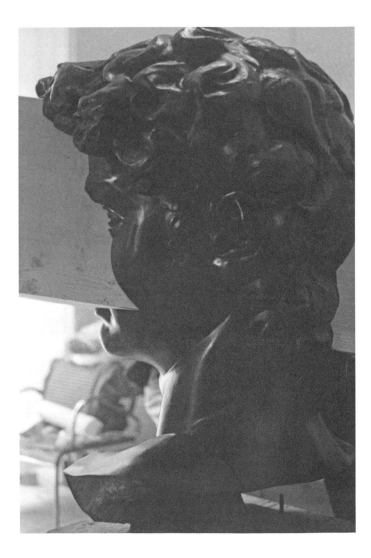

La paille dans l'œil du voisin, 1987.
Bronze, height 118 cm.

Il n'y a plus de signe, 1989.
Marble, height 148 cm.

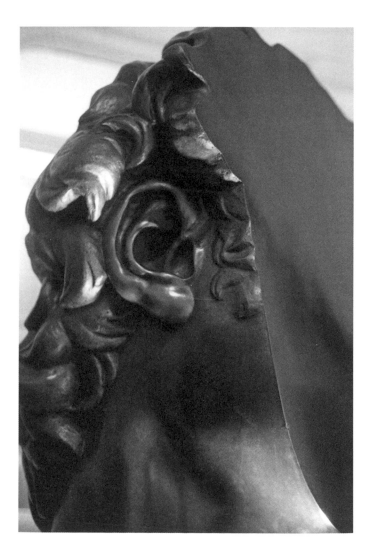

Hommage à David, 1985.
Bronze, height 118 cm.

Dieter Mersch

Levinas and the Ethics of the Arts
An Epilogue

It is well-known that Emmanuel Levinas, the philosopher of alterity, sociality, and ethics as the *prima philosophia*, wrote little about art. Less well-known is that he, as a phenomenologist, saw the aesthetic as the preeminent source of experience of the Other as well as of another experience where the arts, as Hegel first emphasized, take on an essential role on equal footing with the "disclosure of the ethical demand,"[1] and even that all three participate in the same movement under the aegis of ethics. One usually reads Levinas in relation to theology, to the connection between alterity and transcendence, or in consideration of a break with intentionality and the structures of meaning as well as with a view to an ethics of responsivity[2] which gives the Other unconditional priority above all egological claims of the subject. Here, one of the central motifs of Levinas' philosophy, "nakedness itself"[3]— in the sense of bareness, frailty, poverty—"the nakedness of the face," already belongs to the sphere of aesthetics and of

1 See Emmanuel Levinas, "Jean Atlan et la tension de l'art," in Catherine Chalier and Miguel Abensour (eds.), *Cahiers de l'Herne*, Paris 2016, p. 509.
2 See especially: Bernhard Waldenfels, *Sozialität und Alterität. Modi sozialer Erfahrung*, Frankfurt a. M. 2015; idem., *Der Stachel des Fremden*, Frankfurt a. M. 1990; Jörg Sternagel, *Pathos des Leibes*, Zurich, Berlin 2016; Kathrin Busch, Iris Därman, Antje Kapust (ed.), *Phänomenologie der Responsivität*, Munich 2007.
3 "[L]a nudité en soi." Emmanuel Levinas, "La trace de l'autre," *Tijdschrift voor Filosofie,* 25ste Jaarg., Nr. 3 (September 1963), pp. 605–623, here p. 614.

aesthetic experience more broadly, even if only in a disguised manner and, as it were, purified of its profane presence. The *face* or "visage" here apparently refers to the site where not only the otherness of the Other appears as irreducible exteriority but which also seems at the same time to be related to the heterogeneity of art. "Can works of art have a face?" asked Katharina Bahlmann,[4] pointing to the trace of an original resonance between Levinas' aesthetic and ethical reflections which we can also variously connect to a certain topos which was significant for Paul Valéry, Walter Benjamin, Jacques Lacan, and Georges Didi-Huberman: *Ce que vous voyons, ce qui nous regarde.*[5] The images, like architecture, plastic arts, or exhibitions, seem, analogously to social relationships, to possess their own "faces" which offer a "gaze" (Lacan) and whose "facicity" (Deleuze) addresses itself to us and demands that we look at it, which even seems to say to us, like the affectionate face of another: "You shall not commit murder."[6] Something similar can also be said of musical composition and "voice,"[7] which, like the singularity of the face, has something unmistakable and irreplaceable about it[8] to the extent that it directs itself towards us and implores us to listen or at least that we do not pass by without lending it a thought. The plausibility of such analogies certainly lies in this kind

4 Katharina Bahlmann, *Können Kunstwerke ein Antlitz haben?,* Vienna 2008.
5 Georges Didi-Huberman, *Ce que vous voyons, ce qui nous regarde,* Paris 1992.
6 Levinas, *Totality and Infinity,* p. 262. With reference to the image, we would need to reformulate this to: "You will not destroy me."
7 Clearly there is also a certain hesitation to destroy the artwork or even to damage or injure it.
8 See Sabine Till, *Die Stimme zwischen Immanenz und Transzendenz. Zu einer Denkfigur bei Emmanuel Levinas, Jacques Lacan, Jacques Derrida und Gilles Deleuze,* Bielefeld 2013.

of attention and care, as images and other forms of art have a front and reverse side: the former presents itself to us helpless and undisguised and seems to address us directly and, perhaps more importantly, is owed to the effort of another, of an artist, her expressions and her will to expression, however sublimated. And yet this similarity proves to be oversimplified, too superficial, as the point cannot just be "to give a face to things"[9]—for Levinas, the "face" and its ostentatious gaze, which situates, pursues, and even provokes us, is not the function of its simple disclosure, its appearance, but rather above all a "claim" on us. Accordingly, it reveals its ethical power not in direct experience but there where it is perhaps most forceful, where it cannot be reduced to the gaze and its presence. *Visage*, "face" does not refer to a kind of immediacy, perfect note, or innocence which asserts its own singularity; rather, *it appears in not-appearing*, as the missed, paradoxical trace which blurs in being passed by, as the impression of a extinguishing which, in the act of showing, simultaneously points to something that *does not show itself*, something behind it, a darkness which only appears in retreat, there where its presence turns into absence. The thought seems strange and even counterintuitive, and yet Levinas is never concerned with the concrete person, with the "You" (*Thou*) which Martin Buber, for example, placed at the beginning of his dialogic philosophy,[10] a You which concerns us and whose impression we receive. Instead, Levinas is concerned with the "He"—or even more so with "*illeity*"[11]— where the Other is not already

9 Levinas, "Ethics and Spirit," in *Difficult Freedom: Essays on Judaism*, translated by Sean Hand, Baltimore 1990, p. 8.
10 See Martin Buber, *Das dialogische Prinzip*, Gütersloh 1999.
11 Levinas, "The Trace of the Other," *Deconstruction in Context* (1986), pp. 345–359, here pp. 356–359.

a "neighbor" in a Christian sense but rather remains foreign, "different," and thus also unfamiliar. This concerns a deeper dimension, a "transcendence" so to speak, which addresses humanity in the moment of its fragility and dubiousness and its possible eradication, and which evokes a sensibility which remains a pressing issue in times of increasing resentment against migrants. For the concrete face is in fact initially nothing more than a surface whose public nature, as Hans Belting aptly remarked,[12] is a "mask," implying concealment and deception; and yet all of these veils point to a common empty space, an elusive foundation upon which they are superimposed and which they specifically label "human" in order to allow them to participate in a sociality shared by all.

For Levinas, then, it is not the Other, as a basic equal who would be assigned the same rights in the egalitarian order, and not superseded in a mutual relationship as the "conversation which we are" (Gadamer), which creates commonality or community through communication. It is rather that the non-presence of the Other *reveals* itself in the presence of the "face" which erases every carelessness and remains intolerant towards the ignorance which denies its indestructibility, as it is only *through* its concretion that the possibility of a relation comes into being. The origin and irrevocable core of every relationship proves to be this "from-face-to-face," and that before any intentionality, any will to encounter, to perceive, or even understand. And yet this is not primarily given through the senses but rather, as Levinas stresses in his magnum opus *Totality and Infinity*, an "inexhaustible infinite exteriority."[13] We are here confronted with a highly complex philosophical

12 Hans Belting, *Faces. Eine Geschichte des Gesichtes*, Munich 2014.
13 Levinas, *Totality and Infinity: An Essay on Exteriority*, translated by Alphonso Lingis, The Hague 1979.

figuration to which a "conversion" or transformation is inherent which requires the sphere of the aesthetic while pointing far beyond it and in this way also applies to art, which is more than its appearance discloses. For the "en-counter" of a "from-face-to-face"—whether the confrontation with a painting, a song, or a lament, a text or a sculpture, or a fabricated thing, a design object—is originally treble, so that in every relation the dominant "historicity" with its sensual nature and the expression of a withdrawing Other, which at the same time includes a fullness, an excess which cannot be understood as anything but a (literal) "immensity," an "ab-solute" separation or "disruption of the subjective field" in the sense of an "infinity." This means not just a negativity, a mere "withdrawal" into absentness, but also an excess, an exorbitance in the significance of that which exceeds all of our concepts. In this sense, Levinas is able to speak both of "transcendence" and "otherness"[14] or, as he puts it in his second major work, *Otherwise Than Being: Or, Beyond Essence*, a "beyondness" or heteronomy which is above every relation and which cannot be reduced to a being, attribute, or concept and its determination. For art—as for the Other—this means that it does not arise in the perception, in that which has been seen or heard, but rather contains an asymmetry or "non-mutuality"[15] which amounts to unrecognizability, an erasure or a closure, i.e. exactly that "obliteration" which the conversation in the present volume concerns[16] and which, in the emptiness, simultaneously presents the open *per se*. Art as such can only be valid if it does not show "something specific," i.e. is a sign or symbol arising

14 See Emmanuel Levinas, *Otherwise Than Being: Or, Beyond Essence*, translated by Alphonso Lingis, Dordrecht 1991, pp. 10, 17, 19, 140.
15 Levinas, *Totality and Infinity*, p. 215.
16 See pp. 27–41 in this volume.

in its meaning, but rather only if it "overflows," i.e. is chronically "more" than it pretends to present or re-present, if, in other words, it is a "move" and remains in motion, preventing any return. Through its withdrawal it literally "draws" into attention. Thus we read in *Totality and Infinity* that "transcendence precisely refuses totality, does not lend itself to a view that would encompass it from the outside. Every 'comprehension' of transcendence leaves the transcendent outside, and is enacted before its face."[17] And similarly, in *The Trace of the Other*:

> The idea of infinity is desire. It consists, paradoxically, in thinking more than what is thought while conserving it still in its inordinateness relative to thought, entering into relationship with the ungraspable while certifying its status of being ungraspable. Infinity is then not the correlate of the idea of infinity, as though this idea were an intentionality that is fulfilled in its object. The marvel of infinity in the finite is the overwhelming of intentionality, the overwhelming of this appetite for light; unlike the saturation in which intentionality is appeased, infinity disconnects its idea.[18]

The comparison with the granting of a "face", thus only in a limited sense can serve as a paradigm for the development of the aesthetic in Levinas. He tends towards abbreviations and misdirections, misjudging the topos of infinity as the radicality of exceeding all intentions, concepts, or thoughts. The element of "coming from another" is immanent to this topos, which can be neither a model, nor an image or phenomenon, and thus introduces a rift into the aesthetic, at least in its com-

17 Levinas, *Totality and Infinity*, p. 293.
18 Levinas, "The Trace of the Other," pp. 353–354.

mon meaning. The key term *obliteration* refers specifically to this rift. The confrontation with the face of the other, which is always a singular experience, is the central phenomenological motif in the work of Levinas for the manifestation of transcendence and infinity, and this feature can be transferred to art as such. In this sense, the otherness of the Other is not abstract: it becomes apparent in the moment through the faceness of the face (*visage*) as its "reception" and the "hospitality" of its "accommodation";[19] and yet it implies the "presence of exteriority"[20] in the sense of a presence of the "infinitely other"[21] which announces itself in its appearance while equally lacking every concrete expression. "The relationship to the face," we read in the conversations with Philippe Nemo with the title *Ethics and Infinity*, can certainly be mastered through the perception, but the specific feature of the face is that it cannot be reduced to that." Levinas specifically names here "exposition as threat," a helpless surrender as well as the "masks" of an essential "poverty."[22] This doubleness is important in Levinas: the face, in the sense of the *visage* of the presence of an alterity, is something inaccessible to *aisthēsis* and thus also to art. For if this presence were sufficient in its simple physical presence, its phenomenality, it would remain a simple "image" which awakens the idea of a representation of the non-representable, thus also awakening that which, as transcendence and infinity, refuses every arrival. If, in this context, we speak of art as something which is capable of affecting the senses, sight, and perception, we would be positioning exteriority in

19 Levinas, *Totality and Infinity*, p. 254.
20 Ibid., p. 297.
21 Ibid., p. 78.
22 Emmanuel Levinas, *Ethik und Unendliches*, Vienna 1986, pp. 64, 65 [translated from the German] .

the foreground with reference to a finitude and would be repeating a struggle which has already been fought, e.g. during the Byzantine Iconoclastic Controversy, which accused the icon of the sacrilege of reducing the invisibility of God to the perspective of human beings, profaning the "overcoming of the flesh" and housing its holiness in the staleness of material.[23] In contrast, the "site" of alterity is not in this world: instead, it *happens* as the "shining through" which is not transparent but remains *opaque*, through which the shapeless, or that which would reveal a perception, is capable of impenetrably exposing itself—that, in other words, which we could call "inconspicuous." Thus we read in *Totality and Infinity*:

> Man as Other comes to us from the outside, a separated—or holy—face. His exteriority, that is, his appeal to me, is his truth.[24]

And yet, alluding to the already noticeable religious connotations, this is also simultaneously external to every theological label: "This 'curvature of space' is, perhaps, the very presence of God."[25] "The presence of the face," Levinas continues, "is not to be ranked among other meaningful manifestations."[26] It proves instead to be *transsensual*: it exceeds simple being and is *transported* away from every form of sensuality. It is not "sensitive" precisely because it simultaneously "touches" and "unsettles," and we are unable to let ourselves to accept this simply "happening" without being "touched": every face keeps us captive, afflicts us, impinges upon us with

23 See e.g. Marie-José Mondzain, *Bild, Ikone, Ökonomie. Die byzantinischen Quellen des zeitgenössischen Imaginären*, Zurich, Berlin 2011.
24 Levinas, *Totality and Infinity*, p. 291.
25 Ibid., p. 291.
26 Ibid., p. 297.

its mystery and creates a desire which is at the same time an obligation.

For this reason, it also does not depend on *aisthēsis*, on the way a face keeps itself vivid and turns towards us or arouses our imagination, but rather on the immanence of an *enigma*, a "riddle" where, as Levinas puts it in *The Trace of the Other*, a silhouette of God is simultaneously announced.[27] That also means that the face, as an image or expression, intends to say or convey nothing specific; it is not language but rather—in line with Levinas' distinction between "saying" and "the said" —*it reveals itself to be that very secret* which surpasses both, the sense and the senses and, to speak with Nietzsche, cannot as such be discovered fully and conclusively. "Because it is the presence of exteriority the face never becomes an image or intuition,"[28] as we read in *Totality and Infinity*. Rather, *it introduces itself to us* in the same sense, as Levinas writes, that we speak of a person introducing themselves by allowing us to say their name: "This presentation [...] is what we have called the face."[29] In this difficult dialectic, which seeks to apply the term *obliteration* to art, in this simultaneous restriction of a positivity (phenomenon) with a negativity (withdrawal), we can see both the Heideggerian concept of truth, with its duplicity between revealing and concealing and its repeated delay of arrival,[30] as well as the Jewish prohibition of images, which emphasizes the non-presence of God, His unimaginability and unnameability, over his presence, as the metaphor of "eradication," "extinction," "annihilation," or "obliteration" of

27 See Levinas, "The Trace of the Other."
28 Levinas, *Totality and Infinity*, p. 297.
29 Ibid., p. 296.
30 Martin Heidegger, *Der Ursprung des Kunstwerks*, Stuttgart 1960, p. 38ff. See also the afterword by Hans-Georg Gadamer, p. 117ff.

the aesthetic emphasizes the *absence of that which is present* for the sake of the *presence of the absent*. The singular site of aesthetics is thus above all where a gap, a "nothing," is gaping which allows something else to be seen: *presentia in absentia* which is amplified into an *absentia in praesentia*.[31] This is also the reason why *obliteration* cannot be reduced to the simple formula of hiding something to then reveal it, or conceal so as to display it more clearly. Obliteration does not arise from negative theology just as its goal cannot be, like the monochromatic painting of a Mark Rothko or Barnett Newman, to "empty" in order to fill the gaze. Rather, Levinas strongly emphasizes in this conversation that he does not agree with a kind of obliteration which is solely concerned "simply in covering the face with a purely geometric surface. This remains abstract and does not integrate what is covered over."[32] The point is instead to accentuate *the moment of withdrawal itself through art* and thus also the "trait," the "desire" hidden in it, and the gift of otherness we encounter in the face. This simultaneously splits or disrupts the masking in order to bring it into contact with the essential singularity of its "ground." It is the "occasion" or "longing" which alone *gives* knowledge or "truth," instead of simply evoking a non-appearance through its respective negations so as to betray them again to the same degree.

What Levinas is attempting to do in this short conversation is nothing less than suggest that aesthetics cannot satisfy us in either allowing things to appear or in non-appearance as another, different mode of appearance, as long as both remain in consideration, in *meditation* as a form of *disinterested pleasure*. The definition of art is instead based on *entering into*

31 For more on this turn, see also: Dieter Mersch, *Posthermeneutik*, Berlin 2010, Part 1, especially p. 97ff.
32 See p. 34 in this volume.

a relationship, or more precisely: remaining in a relationship with an alterity, an otherness which is never indifferent to us. That means, however, that engagement, like ethics, is from the beginning a matter of *being responsible for something*. Unlike Jean-François Lyotard's interpretation of the avant-garde of a discourse in terms of the "sublime," testifying to the indeterminate and interminable character of aesthetic praxis,[33] Levinas goes a step further and discredits every "obliterating negation" which, to speak with Hegel, persists in the abstract. He instead brings it back to the living relationship, the Other, and the genuinely social conditions which shape us. In the course of this, the arts gain their genuine ethical nature. Nowhere does this concern beauty as such or the brilliance of perfection, as is traditionally held of the aesthetic in its pairing with truth, nor does it concern the *l'art pour l'art* which radically seeks to escape the realm of purposes: instead, as one passage in this dialogue provocatively illustrates, the "immorality" of the Mona Lisa can be seen in its opposing of "evil" and the "suffering" of the world against a simple reconciliatory ideal instead of showing us its vulnerable nearness at the same moment of fragility—in the same way that Theodor W. Adorno questioned the very possibility of poetry in the aftermath of the Second World War and the Shoah, as such poetry could only be silent and thus "barbaric" in view of this crime.[34] Levinas thus accepts *obliteration* when it not

33 Jean-François Lyotard, "The Sublime and the Avant Garde," *Paragraph*, vol. 6, 1985, pp. 1–18.
34 Theodor W. Adorno, "Cultural Criticism and Society," in *Prisms*, Cambridge 1982, p. 34. See also Brecht in 1939: "Was sind das für Zeiten, wo / Ein Gespräch über Bäume fast ein Verbrechen ist / Weil es ein Schweigen über so viele Untaten einschließt!" Bertolt Brecht, "An die Nachgeborenen," in Brecht, *Große kommentierte Berliner und Frankfurter Ausgabe*, Frankfurt a. M. 1988ff., vol. 12, pp. 85–87.

only represents an aesthetic figure which simply plays with the dialectic between opening and closing, but also denounces and exhibits the scandalous which evokes violence, mortality, and injustice, as well as the "wounds" which they leave. This also means, then, that art no longer begins with *obliteration* and its principle of the rift, upon which the work is erected, "but rather in the person," i.e. "in the Other" which has already raised the question of responsibility on its own. Art is thus only art when it does not enchant or does not double that which is and thus transfigure it. Art is only art when it demands distance and consequently triggers reflection about it, a reflection which cannot be a form of ascetics or reluctance but rather the testimony of that which could create a relationship—for, as Françoise Armengaud put it in his conversation with Levinas, "a sculpture offers itself as a model, as a word of address, an injunction. It proposes something, it calls for a response."[35]

35 See p. 39 in this volume.